DOUBLE EXPOSURE

FIGHTING FOR FREEDOM

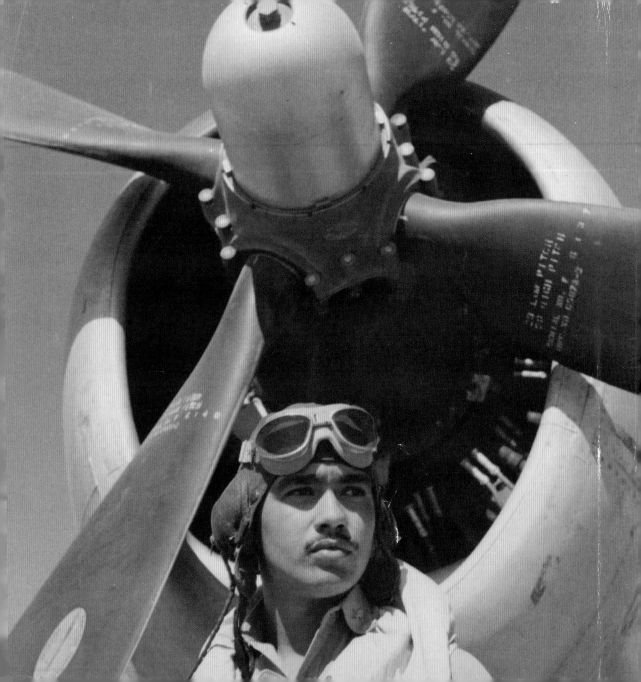

DOUBLE EXPOSURE
FIGHTING FOR FREEDOM

Photographs from the National Museum of
African American History and Culture

Earl W. and Amanda Stafford
Center for African American Media Arts

GILES

National Museum of African American History and Culture
Smithsonian Institution, Washington, D.C., in association with D Giles Limited, London

For the National Museum of African American History and Culture
Series Editors: Laura Coyle and Michèle Gates Moresi
Editorial Assistant: Douglas Remley

Curator and Head of the Earl W. and Amanda Stafford Center for African American Media Arts: Rhea L. Combs

Publication Committee: Aaron Bryant, Rhea L. Combs, Laura Coyle, Michèle Gates Moresi, Douglas Remley, Krewasky Salter and Jacquelyn Days Serwer

For D Giles Limited
Copyedited and proofread by Jodi Simpson
Designed by Alfonso Iacurci
Produced by GILES, an imprint of D Giles Limited, London
Bound and printed in China

Copyright © 2017 Smithsonian Institution, National Museum of African American History and Culture
Copyright © 2016 Gail Buckley
Essay by Charles F. Bolden Jr. titled "Pride in Service" is a Work of the United States Government provided Courtesy of the National Aeronautics and Space Administration.

First published in 2017 by GILES
An imprint of D Giles Limited
4 Crescent Stables
139 Upper Richmond Road
London
SW15 2TN
www.gilesltd.com

All rights reserved

No part of the contents of this book may be reproduced, stored in a retrieval system, or transmitted in any form or by any means, electronic, mechanical, photocopying, recording, or otherwise, without the written permission of the Smithsonian Institution, National Museum of African American History and Culture.

ISBN: 978-1-911282-01-3

All measurements are in inches and centimeters; height precedes width precedes depth.

Photograph titles: Where a photographer has designated a title for his/her photograph, this title is shown in italics. All other titles are descriptive, and are not italicized.

Front cover: Corporal Lawrence McVey in uniform (detail), 1917–19, A. P. Mitchell
Back cover: A soldier taking a photo, 1942–45, Robert Scurlock
Frontispiece: Major Lee Rayford in front of a P-47 Thunderbolt (detail), 1944–46, Robert Scurlock
Page 6: A parade of the Grand Army of the Republic in Louisville, Kentucky (detail), 1895, Strohmeyer & Wyman

FOREWORD
Lonnie G. Bunch III
7

PRIDE IN SERVICE
Major General Charles F. Bolden Jr., USMC Retired
10

HEROES AND TRAILBLAZERS
Gail Lumet Buckley
14

PHOTOGRAPHS
19

INDEX
77

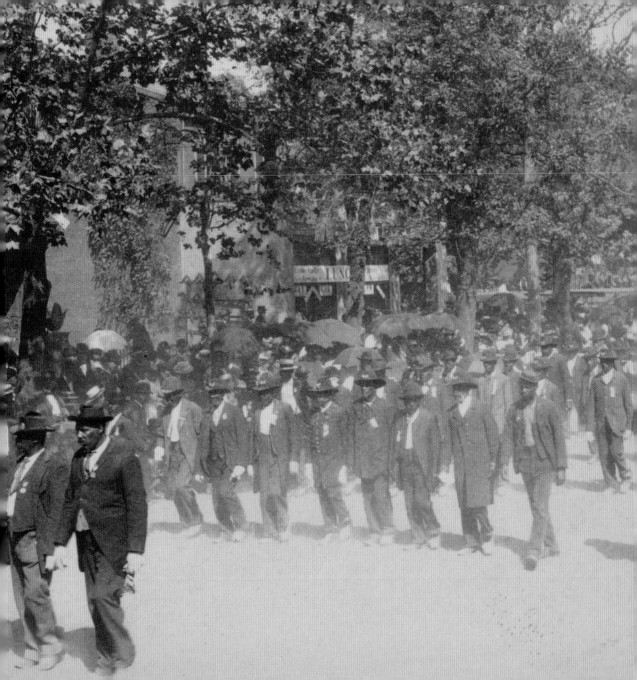

Foreword

The story of African American servicemen and -women exemplifies our nation's struggle with implementing American ideals of freedom and equality. Time and again, since the War of Independence, African Americans have placed themselves in harm's way to fight for liberty and justice, even though they were frequently denied these rights. African Americans, believing deeply in the nation's founding principles, sought to demonstrate their worthiness to have full rights as U.S. citizens. This theme is evident throughout this selection of nearly 60 photographs spanning the Civil War to the current War on Terror. The images in this collection are also a way to remember stories of patriotism, dedication, sacrifice, courage, and dignity.

A rare stereograph in the Museum's collection reminds us of the connection between African American military service and this Museum. It is a photograph of a Louisville, Kentucky, post of the Grand Army of the Republic (GAR) marching proudly in a parade. The largest organization of Union veterans, the GAR allowed African Americans amongst its members, who eagerly participated. However, regional posts were often segregated and many African Americans organized separate chapters. In 1915, black members of the GAR planned to march with white Union soldiers in a parade down Pennsylvania Avenue in the nation's

capital to commemorate the fiftieth anniversary of the Civil War. African American veterans were supported by a "Committee of Colored Citizens," which collected funds to cover the costs of accommodating these vets during their visit to Washington, D.C., a deeply segregated city. Shortly thereafter, the committee re-formed to become the National Memorial Association, which advocated for a "Negro Memorial" and later a national museum to honor "the men and women of our Race.'" A hundred years in the making, this Museum fulfills the hopes of these visionaries, who were inspired by the black soldiers who fought for freedom in the Civil War.

Fighting for Freedom is the fifth book in a series of publications, *Double Exposure*, featuring extraordinary photographs from the Museum's collection. It draws on the Museum's growing photography collection of more than 20,000 images that also supports our innovative Earl W. and Amanda Stafford Center for African American Media Arts (CAAMA). CAAMA, as a physical and virtual resource within NMAAHC, exemplifies the Museum's dedication to preserving the legacies of African American history and culture. The photographs in this volume present varied images of men and women in military service. Such service by African Americans has always carried with it the aim to earn equal treatment as first-class citizens.

Many African American soldiers who, like their white counterparts, left the military after a major war needed to establish a new career. The GI Bill, signed in 1944 to address the problems of veterans readjusting to civilian life, provided much-needed resources for education and training of former soldiers.[2] Many photographers, whose images appear in this volume and throughout the Museum's collection, benefited from photography training as part of their military service or afterwards through the GI Bill. For instance, Henry Clay Anderson, pictured here, who had taught himself to use a box camera as a child, studied photography at Southern University under the GI Bill and went on to photograph the African American community in Greenville, Mississippi, for the next three decades. Robert Scurlock returned from World War II and purchased a building to open the Capitol School of Photography in 1947, with support provided by the GI Bill. Anthony Barboza, pictured opposite, built on his photography skills as a staff photographer in the U.S. Navy and developed photojournalism experience by contributing to the Gosport Naval Air Station Pensacola newspaper.

Talented contributing authors enrich this volume with their unique perspectives. We are honored to have Major General Charles F. Bolden Jr., USMC (Ret.), share his thoughts on what motivated his tremendous service, as well as his insights on a selection of photographs in his essay "Pride in Service." I am grateful to Gail

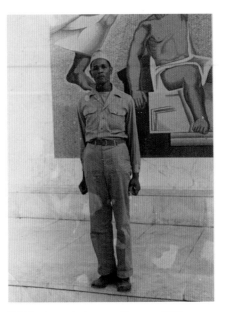

H. C. Anderson in Army uniform, ca. 1945
Unidentified photographer

Buckley, author of *American Patriots*, who highlights key anecdotes of the triumphs and trials of African Americans in the military in her essay "Heroes and Trailblazers." I am also thankful for insightful contributions from Loren E. Miller, Mellon Curatorial Fellow, and to Tulani Salahu-Din, Museum Specialist, who shares her father's personal story and experiences from his time serving during the Korean War.

Many other people collaborated on this important book and landmark series. At the

Museum, special acknowledgement is due to the publications team: Jacquelyn Days Serwer, Chief Curator; Michèle Gates Moresi, Supervisory Museum Curator of Collections, who acted as team leader on this project and as co-editor with Laura Coyle, Head of Cataloging and Digitization, whose work made the reproduction of these photographs possible; Rhea L. Combs, Curator of Photography and Film and Head of the Stafford Center for African American Media Arts; Aaron Bryant, Museum Curator of Photography; Douglas Remley, Editorial Assistant; and Colonel Krewasky A. Salter, U.S. Army (Ret.), Guest Associate Curator of Military History, whose immense knowledge of the history of African Americans in the military provided invaluable input throughout the course of this project. Elaine Nichols, Senior Curator of Culture, assisted this project by providing vital contacts, while support and encouragement from our Associate Director for Curatorial Affairs, Rex Ellis, has been instrumental to the ongoing work of the series.

We are also very fortunate to have the pleasure of co-publishing with D Giles Limited, based in London. At Giles, I particularly want to thank Dan Giles, Managing Director; Alfonso Iacurci, Designer; Allison McCormick, Editorial Manager; Louise Ramsay, Production Manager; and Jodi Simpson, copyeditor and proofreader. Finally, I would like to thank our entire Digitization Team for researching, cataloging, digitizing, and preparing all of the images and captions included in this volume.

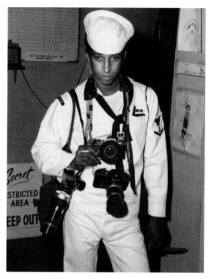

Anthony Barboza in a naval uniform holding cameras, 1966
Unidentified photographer

I am so pleased to continue this series with images of the U.S. military and to share this special selection with our public. The Museum is steadfast in its commitment to documenting African American history, and, like me, I trust you will be inspired by the photography collections at the Smithsonian and beyond.

Lonnie G. Bunch III
Founding Director
National Museum of African American History and Culture, Smithsonian Institution

Pride in Service

Major General Charles F. Bolden Jr., USMC Retired
Twelfth NASA Administrator

The images in this volume offer an insightful view into the long history of African Americans who served our country through the military. They demonstrate the willingness of a people to stand up and be counted, even when they were not always fully recognized in the legal and social systems of their day. They give us a window from which to see a small sample of the hard work and sacrifice that African Americans continue to pour into the greater life of the United States.

As a young man, I knew from my seventh-grade year that I wanted to join the military. Public service was a watchword in my household. Among many examples and role models, I witnessed my father and my uncles, who had proudly served their country in the U.S. Army in World War II. They didn't dwell on the conditions they faced as black men in a segregated military. They talked about what they had done and how they hoped they had made a difference in their own small way in the country's effort to fight for freedom around the world. It was that personal pride and sacrifice that informed my earliest understanding of public service and that I suspect may also have been in the minds of the men and women whose lives are reflected in this volume.

At the time my relatives served, black service members were still fighting their own war on the Homefront, too, in a segregated society. Legendary leaders like the Tuskegee Airmen demonstrated that heroism and patriotism were not a function of skin color. The 332nd Fighter Group and the 477th Bombardment Group of the United States Army Air Forces proudly took these first black pilots to the sky. In addition to the pilots, navigators, bombardiers, mechanics, nurses, and many other support personnel also made it possible for these brave men to break barriers even as they risked their lives. It's been my privilege to meet several of the surviving members of that great cohort and their example inspired many others and me. As I pursued my military career, it was not with the intention of becoming a pilot, but as that began to emerge as a viable choice, I had only to look over my shoulder to find a tip of the wings from the Tuskegee Airmen.

It was one of the great honors of my life to have been able to serve as National Public Affairs Officer of the Montford Point Marine Association—the direct antecedents to my own career in the U.S. Marine Corps. When President Franklin D. Roosevelt signed Executive Order 8802 to ban discrimination in the defense industry, brave men flocked to enlist despite the hardships and discrimination they would face in training at Montford Point, Camp Lejeune, North Carolina, as they sought to serve their country. I am proud to have their number represented in this volume.

The Golden Thirteen, the first African American commissioned and warrant officers in the U.S. Navy, were also among the leaders in these early days of a new military. Although not always welcoming, the services began to change their policies and eventually realize that the skills and dedication of African Americans and other men and women of color were desperately needed in a military sorely tested to meet the demands of the modern world.

By the time of the Vietnam War, when I began my service, the military was fully integrated and race was no longer the issue it had once been. But as the Civil Rights Movement swept the country, so too did notions of service and patriotism as the military continued to evolve. I myself faced challenges simply to attend the U.S. Naval Academy, but it was the example of those who came before that made it possible for me to pursue my dreams of public service.

It is also critical that this book recognizes the accomplishments of women in

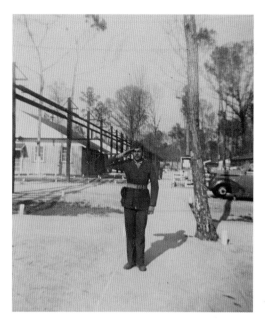

Sergeant Joseph H. Carpenter at Montford Point, Camp Lejeune, North Carolina, ca. 1945
Unidentified photographer

the service, who faced additional challenges of discrimination and societal prejudice as they worked to contribute to their nation's defense in wartime across many decades. My sisters in arms have given their talents and sometimes their lives across many battlefields and continue today to set the bar high for all of us.

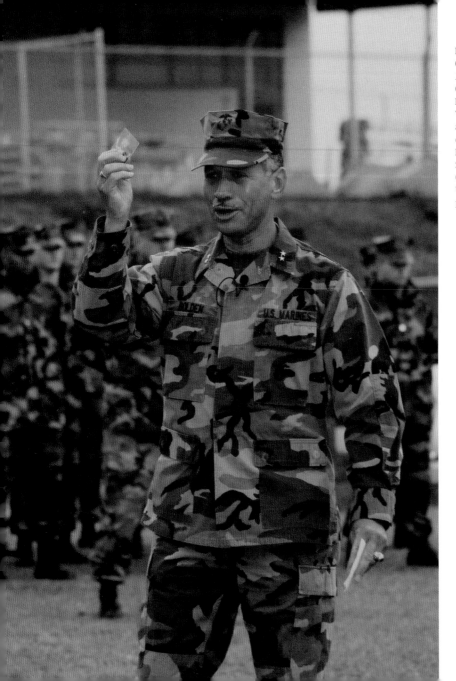

Major General
Charles F. Bolden
Jr., Commanding
General of the 3rd
Marine Aircraft
Wing, addressing
assembled marines
on "core values" at
Marine Corps Air
Station Miramar,
California, 2000-01
Unidentified
photographer

The photos in this book document many more heroic service members, both unknown and those who made names for themselves at a time when their service was not widely recognized—from the Civil War to World War I and beyond. Wartime creates some of the most trying circumstances a human being can endure and its crucible strips away all but the true essence of those who endure the heat of battle. Perhaps in the greater scheme of things, that experience of men and women of all races fighting side by side, suffering injury and loss and also achieving great things, has advanced the necessary cause of racial equality so essential to our future and the outcomes of the battles that lie ahead.

NASA has always depended on the military for well-trained personnel equipped with technological and engineering skills, flight experience, and the ability to work on a team. These include Air Force Officer Guion Bluford, the first African American to fly to space, and many others. It is my hope that the skills and passion that led these men and women to the military will help propel the greater union of all nations as we expand humanity's presence throughout the solar system and demonstrate what nations can accomplish together working peacefully— something certainly beyond the comprehension of a sailor fighting for his rights during the Civil War, but intimately tied to those distant battles.

These images document a people, but they also document individual lives and stories that may never fully be known. However, the determination and pride is evident on the faces in these images, and the lives they represent have left a mark on our world, even if many of the people remain unnamed heroes from a time long past. I honor the service of each and every man and woman in this book, as well as the thousands of others who toiled in anonymity but helped each of us follow our dreams and preserve our American way of life.

An old African proverb states, "Do the best you can, where you are, with what you have, now." African American members of the military have always done that and more. By doing more than making do, by battling on the ground and in the sky, at home and abroad, they have opened our eyes to our own humanity. With these startling images, we can envision our own history anew.

Heroes and Trailblazers

Gail Lumet Buckley
Author of *American Patriots*

Here is a panoramic gallery of heroes and trailblazers—some known by blacks and whites, some by blacks alone. In the eighteenth and nineteenth centuries, black military heroes were celebrated. By the early twentieth century, however, Southern revisionism had replaced the true story of black heroism with the myth of the happy slave—but photographs do not lie.

The Civil War enshrined a photograph of Sergeant William Carney, hero of the storied 54th Massachusetts Infantry Regiment (see p. 26). He leans on a cane because of war wounds, and cradles an American flag that appears to be twice his size. As everyone who saw the film *Glory* knows, the 54th Massachusetts was the first black regiment in the North created after the Emancipation Proclamation. Although badly wounded, Carney, a New Bedford seaman, famously rescued the flag at the Battle of Fort Wagner, South Carolina, in July 1863, where the outnumbered 54th was essentially sacrificed. When the Union troops were forced to retreat,

Carney staggered across the battlefield carrying the flag. "The old flag never touched the ground,"' he said when he reached his own lines. His words became as famous as his action. He received the Medal of Honor in 1900.

By the end of the Civil War, blacks were 10–12 percent of the Union Army, and veterans were the nucleus of the soon-to-be-legendary Indian fighting regiments, the all-black 9th and 10th Cavalries and the 24th and 25th Infantries. Blacks were also appointed to the service academies for the first time. In 1877, the celebrated Henry Ossian Flipper became the first black graduate of West Point. In 1889 Charles Young (see opposite) became the third black graduate, and the last until 1936. All three black cadets suffered ostracism and the silent treatment while at West Point. After graduation Young served in both the 9th and 10th Cavalries. However, when the Spanish-American War broke out in April 1898, Young, the only regular army black officer, was not permitted to go to Cuba with black troops.

The 9th and 10th Cavalries, on the other hand, served abroad under white officers and became famous. "We officers of the Tenth

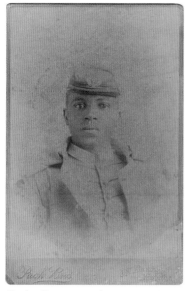

Charles Young as a cadet at West Point, 1889
Pach Brothers

Pancho Villa, after the bandit revolutionary invaded a New Mexico border town and killed seven U.S. soldiers. Major Charles Young and the 10th Cavalry won national fame when they rescued the ambushed 13th Cavalry, an all-white unit. In September 1916, Young was promoted to lieutenant colonel. But a year later, with war waging in Europe, Young was declared unfit for further combat, which stalled his promotion to colonel and prevented him from going to France to fight in the war. The Army brass knew that if Young were to go to France as a full colonel he would have a good chance at returning home as a brigadier general, and white officers would have to serve under him. However, many in leadership positions did not want any black generals. Believing the declaration of unfitness to be both wrong and unfair, Young rode his horse from Wilberforce, Ohio, to Washington, D.C., over a period of sixteen days to prove his fitness for duty. In the face of national publicity, Young was promoted to colonel and called to active duty, but only during the last week of World War I.

Cavalry could have taken our black heroes in our arms,"[2] wrote Lieutenant John J. "Black Jack" Pershing (nicknamed for the color of his troops) after the Battle of San Juan Hill in Cuba, where black cavalry came to the aide of Teddy Roosevelt's Rough Riders. Despite the fact that many American blacks objected to fighting people of color, Charles Young did lead troops during the Philippine occupation.

Later, in March 1916, Pershing led a punitive expedition of five thousand U.S. troops across the Rio Grande in pursuit of

Racism in the military meant that trained black units like the 10th Cavalry stayed in America during World War I. Most African American units that went abroad served as labor troops. African American National Guard units, which formed the 93rd Infantry Division, including the 369th Infantry Regiment ("Harlem's Own"), were offered to the French. The 93rd Infantry Division was

one of only two black combat divisions that served in France. The 369th served more time in the trenches than any other American regiment and was one of the U.S. units most highly decorated by the French, being awarded the first Croix de Guerre given to an American soldier. Corporal Lawrence Leslie McVey (see p. 27) of the 369th earned his Croix de Guerre for bravery during a machine gun attack at Sechault, France, on September 29, 1918. When the war ended, the American government officially requested that the French not mention black American heroism in their memorials and not permit black Americans to march in their victory parades, but African Americans serving abroad was big news in U.S. newspapers. Captured by newsreel cameras, the 369th famously led a victory parade in New York City, to the delirious delight of the crowds.

A little over two decades later, an even more famous group of African American servicemen would emerge on the world stage, the 332nd Fighter Group—the Tuskegee Airmen—America's first black fighter pilots. As fighter escorts over Western Europe and the Balkans, the 332nd flew numerous combat missions over Europe, and were credited with shooting down several German jets. Despite winning hundreds of medals, no American airline or commercial transport company would hire any former Tuskegee Airman after the war. African American women also served in World War II. More than 6,500 volunteered for the Women's Army Corp (WAC). Major Charity Adams commanded the WAC's 6888th Central Postal Directory Battalion, the only all-black WAC unit to serve abroad (see p. 50).

C. Alfred "Chief" Anderson, a legend in black aviation, was among America's earliest black licensed pilots. Pennsylvania-born Anderson fell in love with flying as a youth in the 1920s, but was limited to aviation ground school because no flying school would accept him. After saving and borrowing enough to buy his own used single-engine plane, he joined a white flying club and, still without lessons, taught himself to take off and land. In 1929, aged 22, he finally earned a pilot's license, and in 1932 became one of the first African Americans to receive an air transport pilot license from the Civil Aeronautics Administration. In 1938, Anderson became flight instructor for the Civilian Pilot Training Program (CPTP) at Howard University. The CPTP was a government program to train civilian pilots, but the purpose was also to promote military readiness. In 1940, Anderson was named Chief Civilian Flight Instructor for the new program to train black pilots at Tuskegee Institute. In March 1941, Anderson achieved national publicity when

he gave Eleanor Roosevelt a forty-minute flight over Tuskegee.

Pictured here with Anderson, Daniel "Chappie" James Jr. became the first black commander of an integrated U.S. Air Force squadron in 1951, flying more than one hundred Korean combat missions, switching mid-war from World War II mustangs to jets. As an unarmed jet reconnaissance pilot over North Korea, James was shot down behind enemy lines and rescued by a U.S. Marine Corps tank crew. Later, flying more than seventy-five missions over Vietnam, he and white "triple ace" Colonel Robin Olds were a celebrated Vietnam team known as "Black Man and Robin." In 1975 James became the first African American to reach the rank of four-star general.

During the Vietnam War, Chappie James was criticized by some blacks as a war apologist. The first U.S. war to begin with blacks and whites serving as equals under the American flag, the Vietnam War in its early years has been described as a period of racial "sweetness and light." But, by the mid-1960s, many African American soldiers asserted themselves in the face of riots and assassinations in the United States. For the first time in U.S. military history, black soldiers demanded to be seen as "black," insisting on their right to use black pride, Black Power,

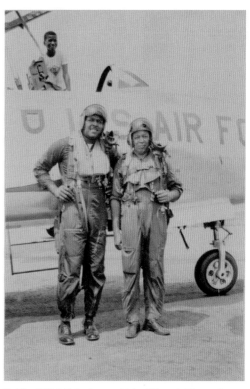

C. Alfred "Chief" Anderson, Major "Chappie" James Jr., and Daniel James III at Otis Air National Guard Base, Massachusetts, August 1955
Unidentified photographer

and "soul" symbols such as handshakes and salutes (see p. 76).

After Vietnam, the military strove to recreate itself: now entirely integrated, it became all-volunteer and co-ed. In the years following the war, many African

Americans signed up because the military offered numerous opportunities for training, education, and advancement that were often difficult to come by in civilian life. By 1980, 42 percent of the black men aged 19–24 who were eligible for the service joined the military, three times the percentage of white men in the same group. African Americans today still serve disproportionately, but make up a significantly lower percentage of forces than they did thirty-five years ago. Now one in five Americans serving in the military is black.

Officers who served during the post-Vietnam military conflicts often began as General Colin Powell did, as a member of the Reserve Officer's Training Corps. After graduating in 1958 and receiving a commission as an Army second lieutenant, Powell went through basic training at Fort Benning before serving in Vietnam in the early 1960s. After being stationed at Fort Carson, Colorado, he became senior military assistant to Secretary of Defense Caspar Weinberger. In 1983 he was promoted to major general, and in 1986, as a newly promoted lieutenant general, he took over the command of the V Corps in Frankfurt, Germany. Attaining the rank of four-star general in April 1989, Powell was selected by President George H. W. Bush to be Chairman of the Joint Chiefs of Staff, the highest military position in the Department of Defense, a post he held until 1993. After retiring from the

military, Powell served as Secretary of State from 2001 to 2005.

Black women have also had distinguished careers in the military, though only a few women to date have reached the highest ranks. Admiral Michelle J. Howard, a graduate of the United States Naval Academy, was the first African American woman to become a four-star officer and the first woman to earn four stars in the U.S. Navy. She served in the Gulf Wars and was part of the peacekeeping effort in the former Yugoslavia. In March 1999, she took command of the USS *Rushmore* and became the first African American woman to command a warship in the U.S. Navy. From 2014 through May 2016, she served as 38th Vice Chief of Naval Operations, the second-highest-ranking commissioned officer in the Navy, the first and only woman to hold this post.

On June 7, 2016, Adm. Howard was appointed commander of U.S. Naval Forces Europe, commander of U.S. Naval Forces Africa, and commander of Allied Joint Force Command Naples.

This publication celebrates the heroes and trailblazers, such as Carney, Young, Powell, and Howard, as well as the hundreds of thousands of accomplished African Americans who have served their country. They have proved that all heroism is equal in the face of armed conflict—as, of course, it should be.

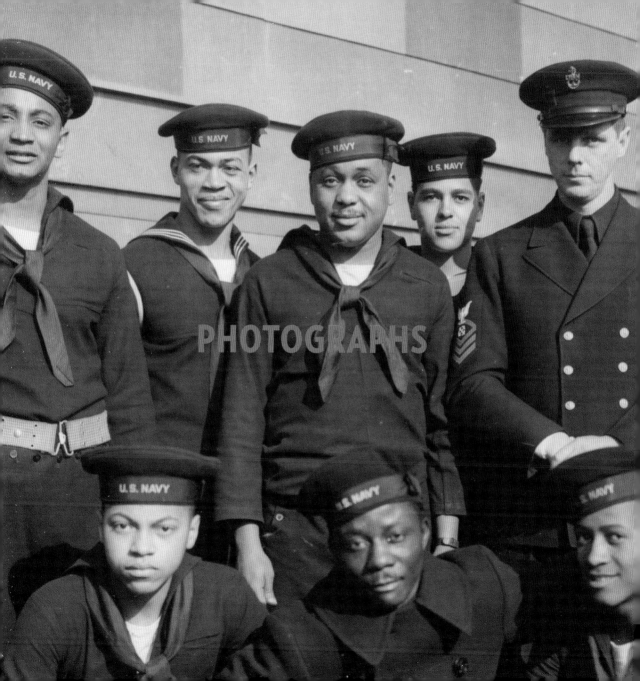

PHOTOGRAPHS

Captain William A. Prickitt's photograph album of the 25th Regiment USCT soldiers, 1864–65
Unidentified photographer

—

Approximately 179,000 African American men served in the Union Army—16 are pictured here. This miniature album, reproduced at actual size, belonged to Captain William A. Prickitt, who led Company G, 25th Regiment United States Colored Troops. According to family lore, Capt. Prickitt had created the album after he had survived a near-deadly bout of influenza; the captain claimed he would have died had it not been for the care and attention of his soldiers. The album was a keepsake to remember his loyal and dedicated troops.

"MEN OF COLOR To Arms! To Arms!... we must rise up in the dignity of our manhood, and show by our own right arms that we are worthy to be freemen."

Recruitment broadside written by Frederick Douglass, 1863

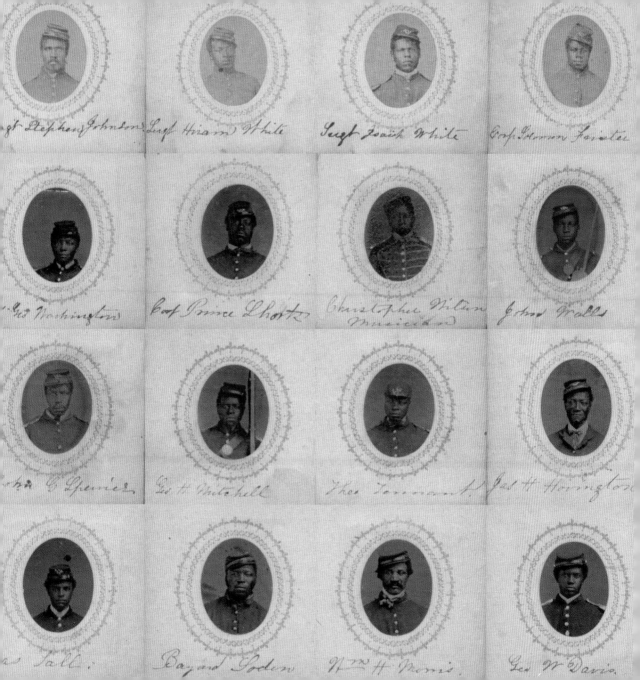

St. Stephen Johnson Sergt Hiram White Sergt Isaac White Corp Solomon Foster

Geo Washington Corp Prince Short Christopher Wilson Musician John Walls

John C Spencer Geo H Mitchell Thos Tennant Jas H Harrington

Wm Hall Bayard Soden Wm H Morris Geo W Davis

**Creed Miller's star-
shaped military
identification pin
and photo**, 1864
Unidentified
photographer
—

The small silver Civil
War identification badge
pinned next to the tintype
belonged to Creed Miller,
who fought to destroy
slavery as a soldier in
the United States Colored
Troops. Miller enlisted
in Lebanon, Kentucky,
not far from where he
had once been held in
bondage. The young man
in the portrait, assumed to
be Miller, certainly carries
the air of a man proudly
self-possessed. Both the
pin and the photograph
speak of freedom—one
that was fought for in
battle and one more
deeply personal that
resided within.

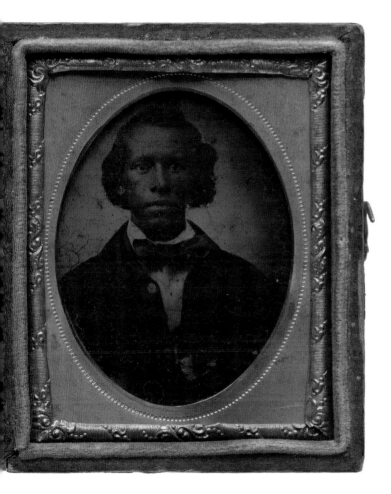

**Members of the
55th Massachusetts
Infantry**, 1863–65
Unidentified
photographer

—

Taken in the summer
of 1863 at their training
camp in Readville,
Massachusetts, this
large-format photograph
of the 55th Massachusetts
Infantry shows two
officers and fifty-eight
men in uniform ready for
deployment. The 54th
Massachusetts Infantry
had been oversubscribed,
so the 55th was created
as a result. The 55th had
engagements in Florida and
the Battle of Honey Hill, and
served on Folly and Morris
Islands as part of the
siege of Charleston. The
55th was one of the first
regiments—and the first
black regiment—to march
through Charleston after
the city was evacuated by
Confederate forces.

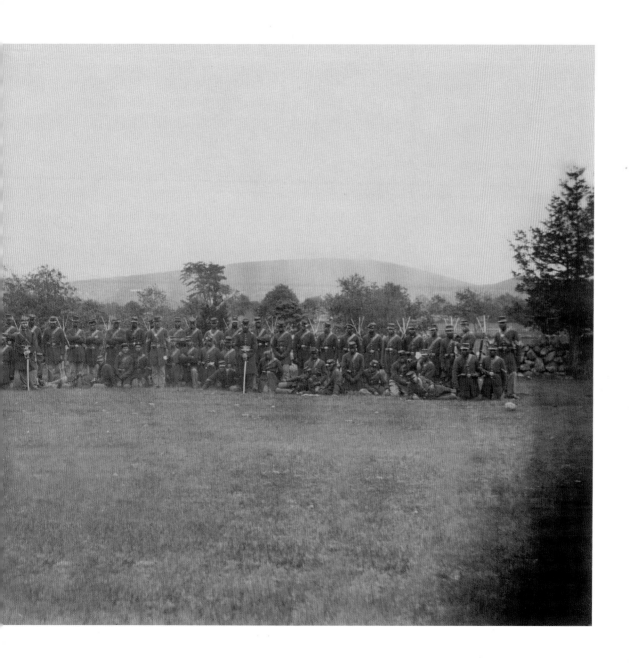

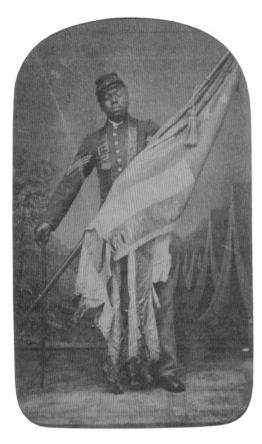

Sergeant William Carney holding a flag, ca. 1864
John Ritchie

—

The Medal of Honor was the first official military medal awarded for valor on the battlefield, and it is fittingly our nation's highest military honor. Sergeant William Carney was subsequently awarded the Medal of Honor for his actions at Battery Wagner on July 18, 1863, during the Civil War. He is one of eighty-nine African Americans awarded ninety Medals of Honor—Ordinary Seaman Robert Augustus Sweeney was awarded the Medal of Honor twice during the 1880s. In 1861, during the Civil War, President Abraham Lincoln signed into law the Navy Medal of Honor; the Army Medal of Honor followed in 1862. Almost a century later, in 1960, the Air Force Medal of Honor was signed into law. Due to racial bias, no African Americans had been awarded the Medal of Honor during the World Wars. It was not until 1991 that the first African American veteran from World War I was awarded the Medal of Honor. In 1997, seven African Americans were awarded the Medal of Honor for their service in World War II.

Corporal Lawrence McVey in uniform,
1917–19
A. P. Mitchell

—

World War I soldiers serving in the 369th Infantry Regiment, nicknamed the "Harlem Hellfighters," received the highest honors from the French government, the Croix de Guerre, for their bravery and actions in battle. Corporal Lawrence McVey was among the returning soldiers who were hailed as heroes and welcomed in Harlem with cheers and celebration when they marched down Fifth Avenue in New York City in February 1919.

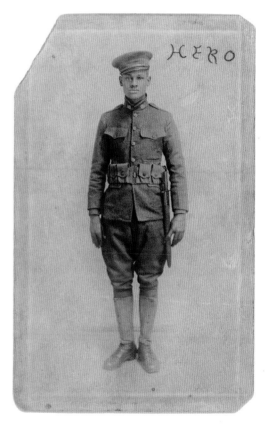

"Neither you nor I nor any other red-blooded black man wants to take an unfair advantage over our comrades in this go round. We want all that we have to come from merit, gain, hard work and the mercies of a good God."

Letter to Sergeant Oscar W. Price from
Colonel Charles Young, August 14, 1918

Private Thomas White, Company B, 24th U.S. Infantry, 1899
O. M. Hofsteater

—

This photograph of 18-year-old Private Thomas White was taken in Vancouver, Washington. Pvt. White and fellow soldiers of the 24th Infantry's Company B were stationed at Vancouver Barracks from April 1899 to May 1900. The arrival of Company B marked the first time in the history of the post that a unit of Buffalo Soldiers comprised the post's regular garrison of troops. Company B left Vancouver Barracks after a year to serve valiantly in the Philippines.

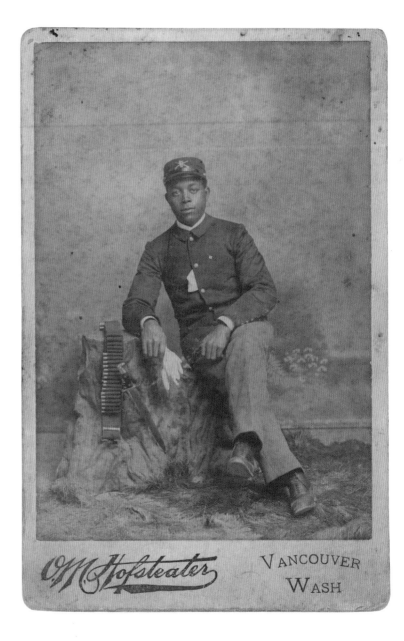

Bosey E. Vick,
1914–18
Unidentified
photographer
–
Bosey E. Vick first enlisted as a private in the 25th Infantry in 1907. Although he was on active duty during World War I, Vick and his fellow African American soldiers of the 25th Infantry spent the entirety of the war assigned to garrison duty in Hawaii and did not see combat. By 1922, Vick was discharged, having attained the rank of master sergeant. After his service, Vick became a porter for the Pullman Company.

"Officers and enlisted men of my regiment are undergoing rigid training, mentally and physically. Our greatest aim is to maintain our standing among American soldiers and add another star to the already brilliant crown of the Afro American soldier."

M. W. Saddler to *The Freeman* newspaper, September 1899

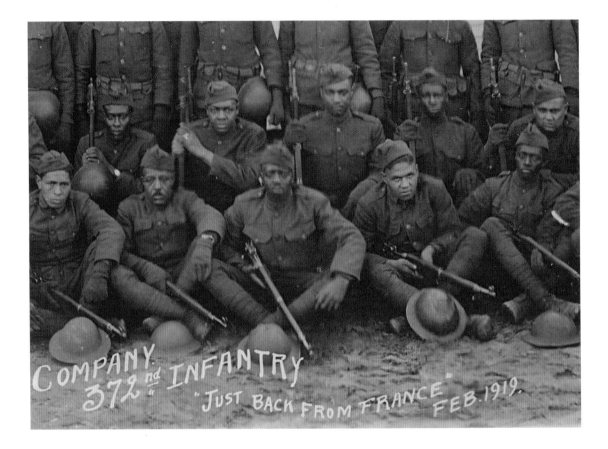

Just Back from France,
February 1919 (detail)
Thompson Illustrograph
Company

Just Back from France,
February 1919
Thompson Illustrograph Company

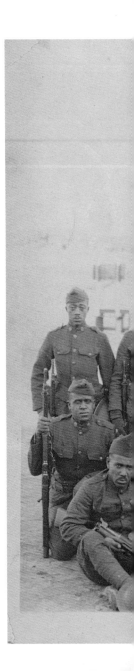

Peter L. Robinson Sr.,
ca. 1917
C. Bruce Santee
—

First Lieutenant Peter L. Robinson Sr. served in the 368th Infantry during World War I. After his army service he graduated from law school and taught military science at Armstrong High School in Washington, D.C.

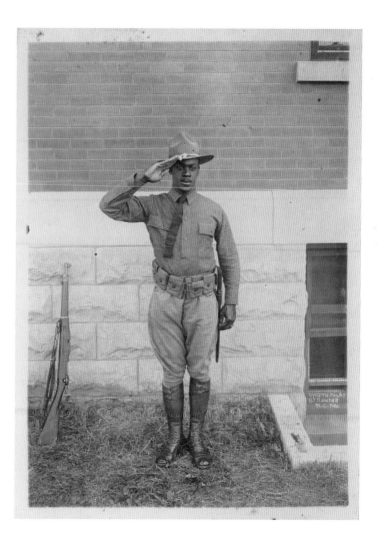

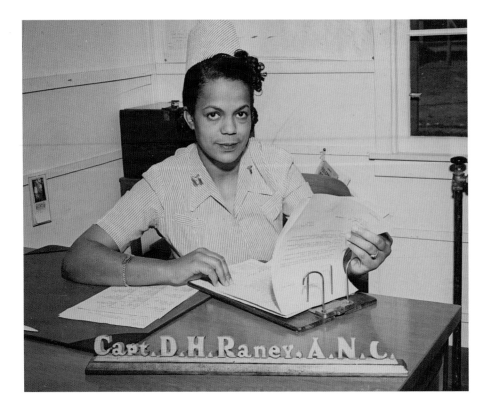

Captain Della H. Raney at the station hospital at Camp Beale, California, April 11, 1945
Office of War Information

—

In 1941, Della Hayden Raney (later Della Hayden Raney Jackson), a 1937 graduate of Lincoln Hospital School of Nursing, became the first African American since 1919 in the Army Nurse Corps. Commissioned as a 2nd lieutenant, her first tour was at Fort Bragg, North Carolina, where she was promoted to 1st lieutenant. During World War II, she served as Chief Nurse at Tuskegee Army Airfield, Alabama, and at Fort Huachuca, Arizona, and as head of the nursing staff at the Camp Beale, California, station hospital, where she was promoted to captain in 1945. Promoted to major the next year, Raney served a tour of duty with the occupation force in Japan. Major Raney retired in 1978 after earning the highest rank of any African American nurse who served in World War II.

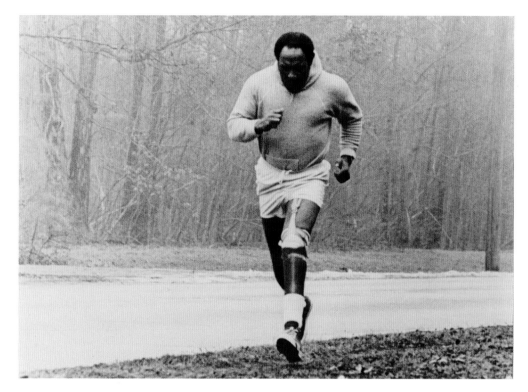

Carl Brashear
running, after 1966
Unidentified
photographer
—

Carl Brashear joined the Navy in 1940 and fought racism to gain admittance in the Navy's elite diving school. Despite facing discrimination, Brashear graduated in 1955 and went on to become a first-class deep-sea diver in 1964. Two years later, a pipe crushed his leg while on duty; he decided to have it amputated and to be fitted for a prosthesis so he could continue diving. After rehabilitation, Brashear passed rigorous testing to become the first amputee certified as a U.S. Navy diver. In 1970 he made history a second time when he became the first African American to earn the Navy's highest ranking of master diver.

African American Service Women in World War II

During World War II the U.S. Army, Navy, Coast Guard, and Marines made the controversial decision to create Women's Reserves, which allowed women to join the military. Due to the debate surrounding women entering the armed forces, all of the branches emphasized the importance of their public images. The Reserves realized the country would be watching servicewomen very closely and tried to show them as feminine, respectable, and refined to gain national acceptance. The armed forces created strict recommendations regarding servicewomen's self-presentation—military guidelines told them how to style their hair, apply cosmetics, and even how many calories to eat. In order to further shape their public images, the Reserves also firmly controlled photographic images of servicewomen.

Many African American women saw military service as an opportunity to serve their country, demonstrate their citizenship, and fight racism. But when they tried to enlist, they faced discrimination, exclusion, and segregation in the new Women's Reserves, as well as in the already established U.S. Army Nurse Corps and the Navy Nurse Corps. Realizing the scrutiny they would encounter, African American servicewomen recognized the significance of creating a positive public image. So, many women used the Reserves' guidelines for self-presentation to fight racism in the military and show the importance of their contributions in society. Despite their resourcefulness, black servicewomen continued to face challenges throughout the war. Yet, this did not stop them; they fought the gender and racial discrimination they experienced and broke down barriers to serve in almost every branch during World War II. Over seven thousand African American women joined the military in World War II, with the majority of those serving in the Army followed by the Army Nurse Corps, the Navy, the Coast Guard, and the Navy Nurse Corps.

Loren E. Miller, 2016

A lieutenant in the Army Nurse Corps, 1941–45
Gaston L. DeVigne II

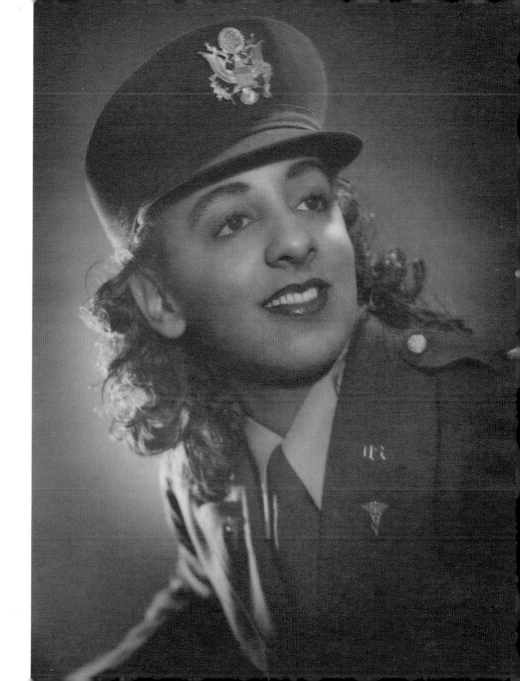

**Major Lee Rayford
in front of a P–47
Thunderbolt**, 1944–46
Robert Scurlock
—

During World War II,
African Americans in the
military fought two wars.
First there was the global
war against fascism. Then
there was a domestic
war against racism in
the United States. Many
Americans argued that
African Americans lacked
the intelligence, skill, and
patriotic courage to serve
the nation and its military,
particularly as pilots.
The Tuskegee Airmen,
however, set out to prove
otherwise. Tuskegee
pilots exemplified African
American love of country
and proved they could
excel as pilots, engineers,
and leaders. The heroic
image of Tuskegee Airmen
as fearless strategists
and intelligent epic heroes
was leveraged to recruit
support and build morale
in African American
communities. This image
still lives with us today.

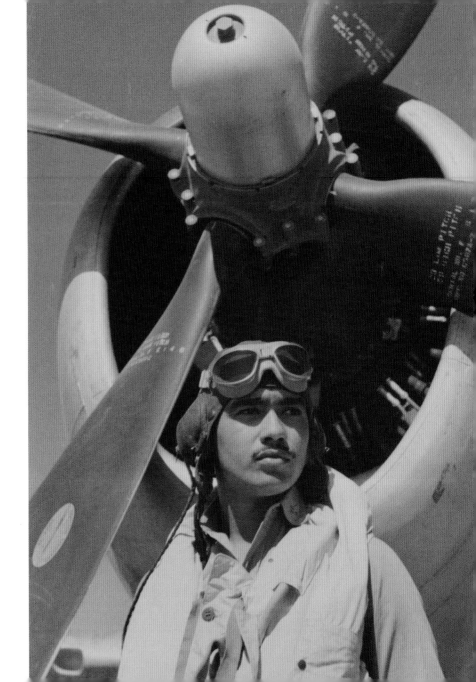

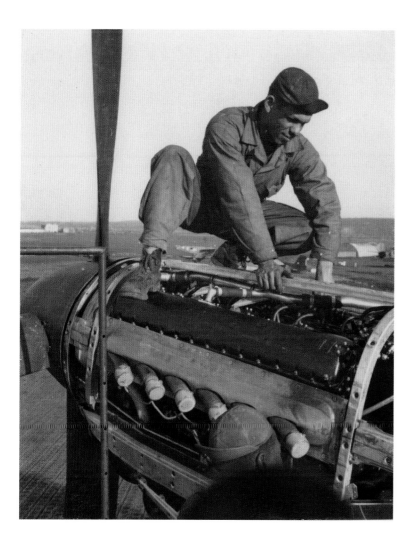

Tuskegee mechanic servicing a P–51 Mustang, 1941–45
James H. O'Neal
—

Tuskegee support personnel numbered 14–15,000, including nurses and mechanics, who kept the more than 900 Tuskegee pilots airborne. A "crack" mechanic was the difference between life and death for pilots and could often diagnose a plane by the engine's roar upon landing approach. In at least one case, a Tuskegee fighter pilot named his aircraft "Kitten" after both his wife and his mechanic. The mechanic, he said, "kept my plane purring like a kitten," a testament to the high esteem pilots held for their mechanics.[1]

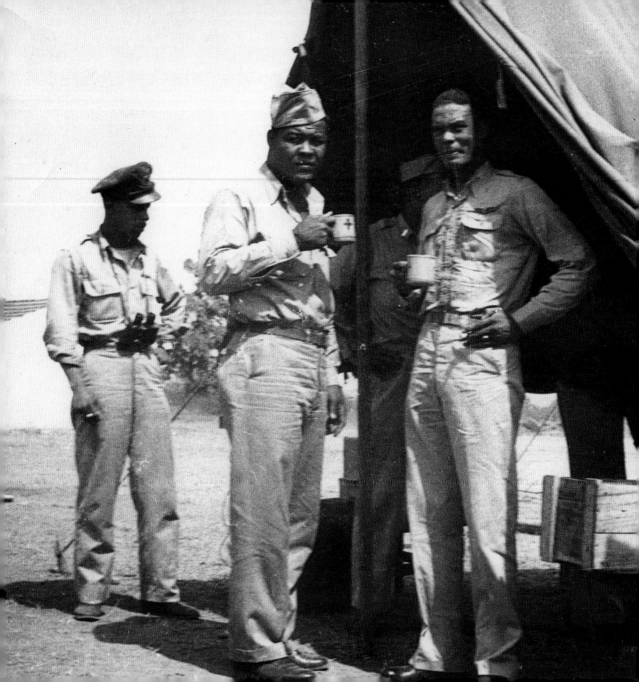

Joe Louis and Commander Benjamin O. Davis Jr. at Ramitelli Airfield, Italy, 1944
James H. O'Neal
—

General Benjamin O. Davis Jr. (right) was the son of Benjamin O. Davis Sr., the first African American general in the United States military. A West Point graduate, Davis Jr. was among the first African Americans admitted to the Army Air Corps for pilot training. He was quickly promoted to lieutenant colonel and given command of the 99th Pursuit Squadron, the first group of Tuskegee Airmen. In 1943, Davis Jr. helped form and commanded the 332nd Fighter Group, which included the 99th and three other squadrons.

The younger Davis is seen here with Joe Louis (left), who enlisted in the military in 1943. The U.S. Army placed the boxing champ in the Special Services Division, where he toured the United States and Europe as a military ambassador. Louis helped raise morale during a time of war. In his celebrated defeat of German boxer Max Schmeling in June 1938, Joe Louis became a symbol of good triumphing over evil. In 1945, the Army promoted Louis to technical sergeant, and by September that year, he was awarded the Legion of Merit.

"Pvt. Joe Louis says—'We're going to do our part...and we'll win because we're on God's side.'"

World War II recruitment poster

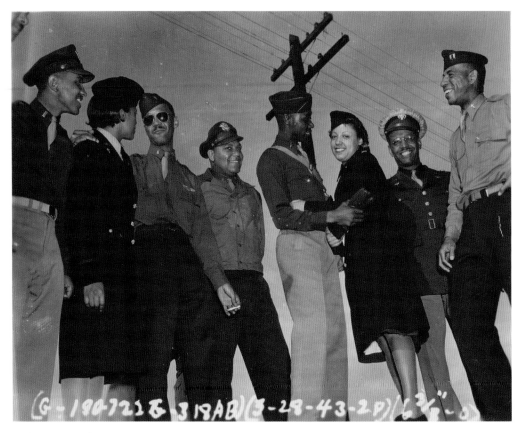

**Officers at Tuskegee
Army Airfield**,
March 28, 1943
Unidentified
photographer

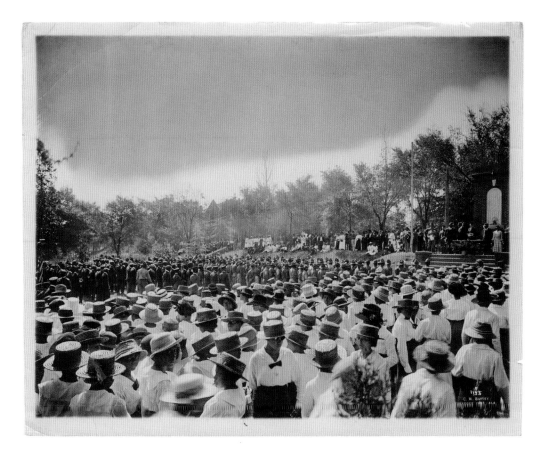

**Military training
graduation at Tuskegee
Institute**, ca. 1916–18
Cornelius M. Battey

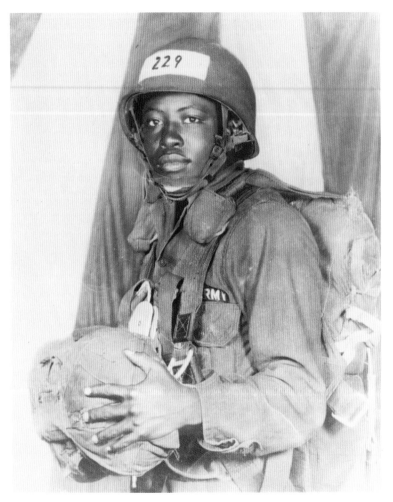

A paratrooper in uniform, late 1950s–early 1960s
Unidentified photographer
—
This paratrooper is likely a student in airborne school judging by the number on his helmet and photo style. Helmet numbers generally corresponded to the last name of airborne students—by alphabetical order—and were identification tools for the school cadre. Class pictures such as this would usually be taken as close as possible to graduation date. The white nametag suggests this image dates from the late 1950s to early 1960s. The parachute on his back is his main chute and the one across his stomach is his reserve parachute—there as a safety mechanism. Graduation chutes were generally "dummies" used over and over for these photographs.

Machine Gun Instruction,
August 25, 1937
Works Progress
Administration
—

The men pictured here
of the 372nd Infantry
Regiment are training
on a Browning M1917
machine gun during the
pre–World War II years at
Camp Edwards in Bourne,
Massachusetts. Between
1935 and 1940 the WPA,
originally established
as the Works Progress
Administration (renamed
the Works Projects
Administration in 1939),
constructed sixty-
three buildings at Camp
Edwards and two runways
at neighboring Otis Field.
This photograph was
likely documentation for
the WPA project at Camp
Edwards. During World
War II, Camp Edwards
served as a departure
point for troops and
training ground for anti-
aircraft units.

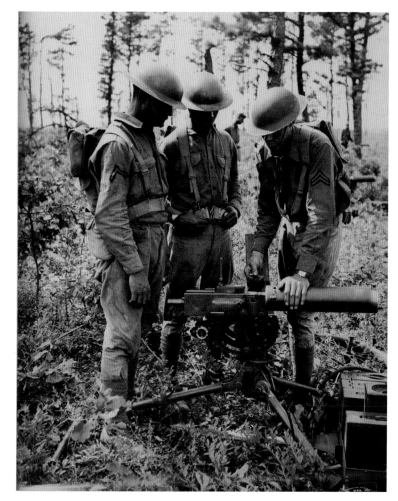

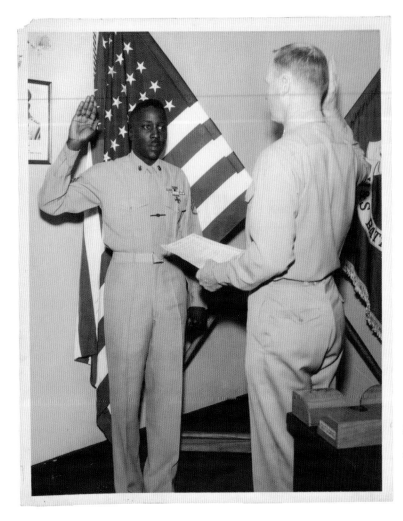

Marine Master Sergeant Thomas J. Williams taking an oath, ca. 1960
Unidentified photographer

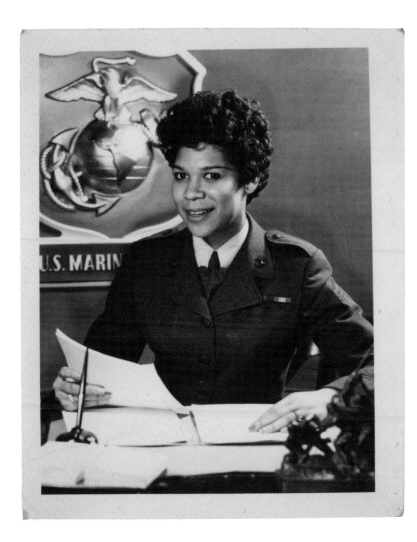

**A Marine sergeant
sitting at a desk**,
after 1954
Unidentified
photographer

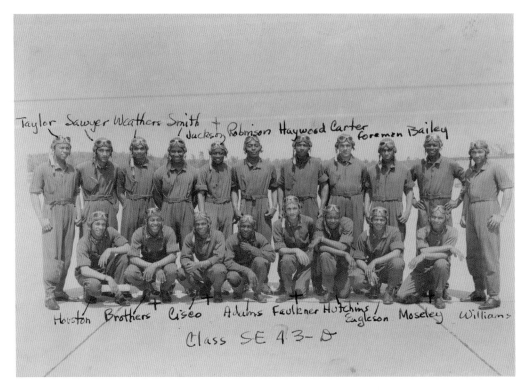

**Tuskegee Airmen
class SE–43–D**,
April 29, 1943
Unidentified
photographer

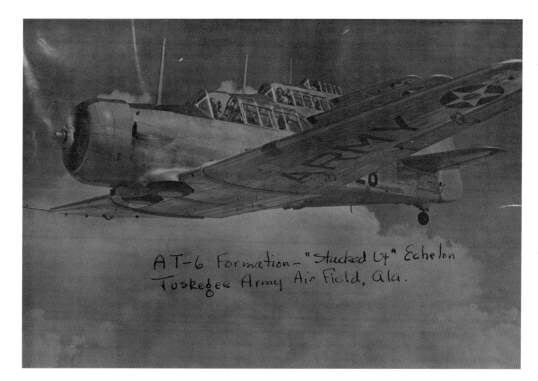

AT-6 Formation- "Stacked Up" Echelon
Tuskegee Army Air Field, Ala.

Three AT-6 training planes in a "stacked-up" echelon formation at Tuskegee Army Air Field, 1943
Unidentified photographer

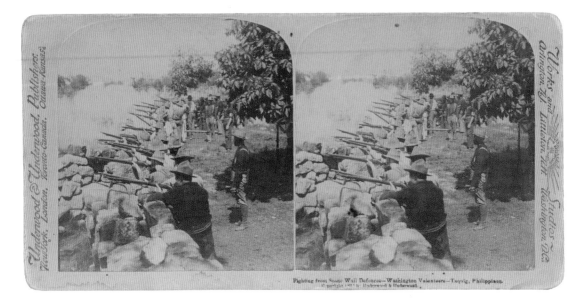

Fighting from Stone Wall Defences — Washington Volunteers — Taguig, Philippines.
Copyright 1899 by Underwood & Underwood.

Fighting from Stone Wall Defences – Washington Volunteers – Taguig, Philippines, 1899
Underwood & Underwood

"The privileges of being an American belong to those brave enough to fight for them."

Benjamin O. Davis Jr.

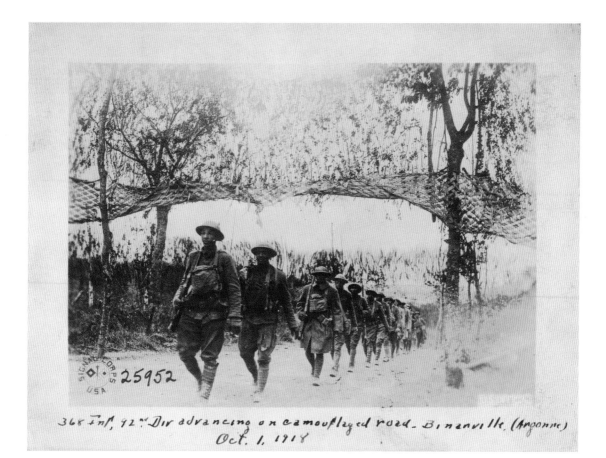

368 Inf, 92nd Div advancing on camouflaged road - Binarville (Argonne)
Oct. 1, 1918

368th Infantry, 92nd Division, advancing on a camouflaged road in Binarville, Marne, France,
October 1, 1918
United States Army Signal Corps

—

Pictured here are soldiers during the Meuse-Argonne Offensive. Also known as the Battle of the Argonne Forest, the Meuse-Argonne Offensive was the largest in United States military history up to that point, involving 1.2 million American soldiers. The battle that began five days before this photo was taken ended on November 11, 1918, with the signing of the Armistice that led to the end of World War I.

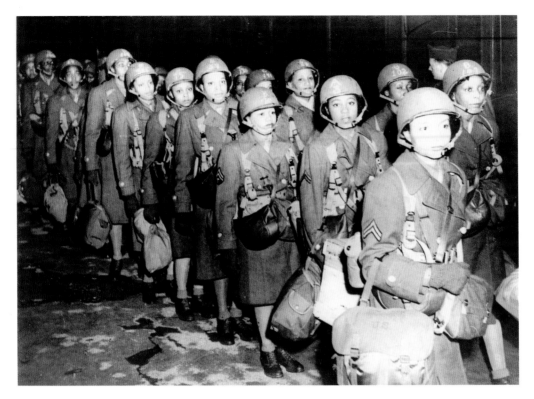

6888th Central Postal Directory Battalion embarking from New York Port, 1945
United States Army Signal Corps

—

Mail was essential for the morale of the seven million Americans serving in Europe during World War II. However, by early 1945, warehouses in Birmingham, England, held a backlog of millions of pieces of mail intended for U.S. personnel. To sort and route this mail, the Army sent the 6888th Central Postal Directory Battalion, which was made up of 854 African American women drawn from the Women's Army Corps (WAC), the only African American WACs to serve abroad. Nicknamed the "Six Triple Eight," they cleared the backlog in three months.

In June 1945, the Six Triple Eight was sent to Rouen, France, where they faced and processed an even larger backlog, and then served briefly in Paris. After the 6888th returned to Fort Dix, New Jersey, in February 1946, the battalion was disbanded.

James Lane and crew members aboard the USS *Indianapolis*,
July 1942
United States Navy
—
During the first few years of World War II, most African Americans in the Navy could only serve as stewards or messmen on seagoing vessels. In July 1942, James Lane and twelve other African American crewmembers in battle dress and their white officers were photographed on board the USS *Indianapolis* somewhere in the Pacific Ocean. Although technically barred from serving in combat positions, these African American men volunteered for additional duty as gunners and are pictured wearing a mix of leftover World War I–style helmets and the new M-1 type helmets worn by white sailors during the period.

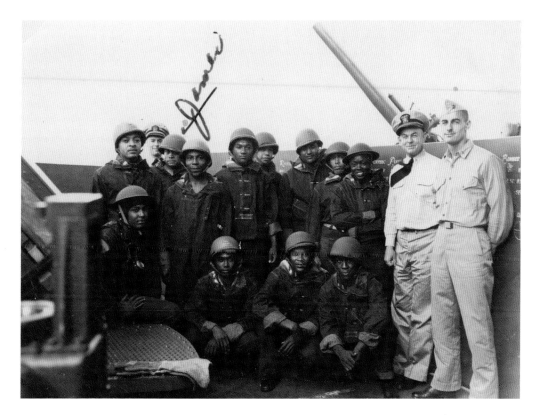

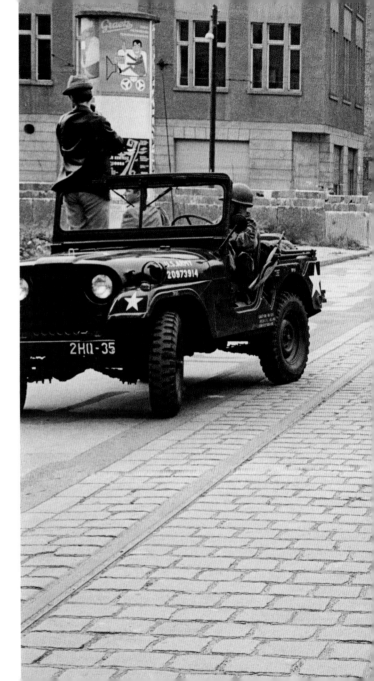

West Berlin · Germany,
1962; printed 2006–9
Leonard Freed

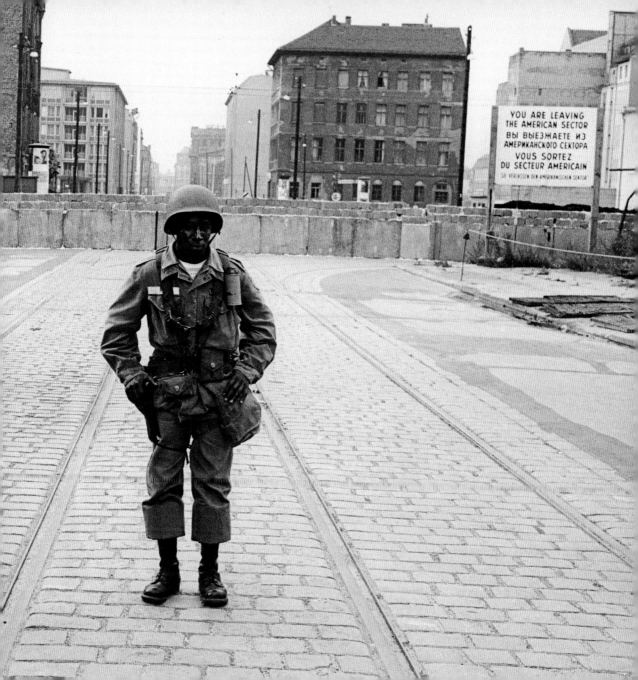

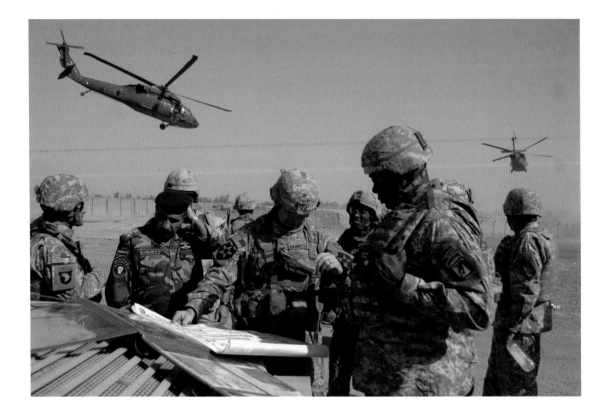

U.S. Army Lt. Gen. Lloyd J. Austin III, Commander of the XVIII Airborne Corps, U.S. Army Col. Jeffrey L. Bannister, Commander of the 2nd Infantry Brigade Combat Team, and **Iraqi Brig. Gen. Abdulah Discuss Troop Progress during a Meeting in East Baghdad, Iraq, on Sept. 11, 2007**
Specialist Nicholas Hernandez

General Lloyd J. Austin III, Commander, United States Central Command, and Former Commanding General, United States Forces–Iraq,
2011
Staff Sergeant Caleb Barrieau
—

A 1975 graduate of West Point, General Lloyd J. Austin III epitomizes the phrase "a soldier's soldier." During Gen. Austin's retirement ceremony in April 2016, Army Chief of Staff General Mark A. Milley remarked, "General Austin is the only general officer in the United States military of any service who has commanded in combat at every rank as a general in the last 15 years." Gen. Austin helped to spearhead the attack of the 3rd Infantry Division into Iraq as a brigadier general (one star) in March 2003. He later served as the general (four star) commander of United States Forces–Iraq in December 2011 when the U.S. ended combat operations there. With these accomplishments, he is considered the first American general in and the last American general out of Iraq during official combat operations.

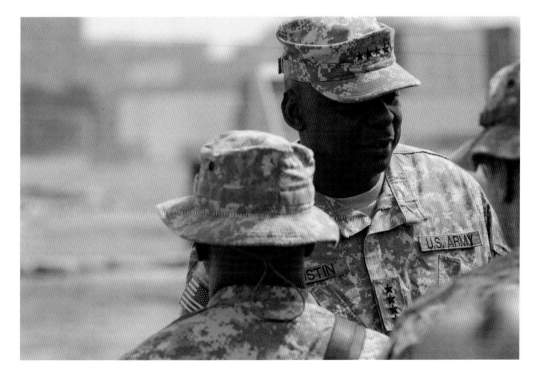

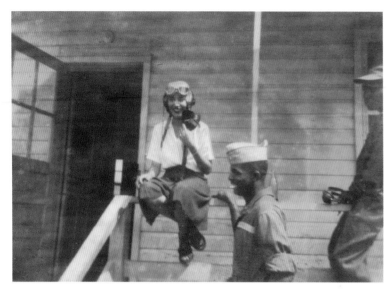

**Bernice Gibbons and
two men at Tuskegee
Army Airfield**,
1943–46
George Evans
Wanamaker Sr.

"When we were all together...[my
friends] would put on their radios, they
would be dancing and singing, and just
having a good time."

Sergeant Bernice Thomas (Women's Army Corps),
in *To Serve My Country, To Serve My Race*, 1997

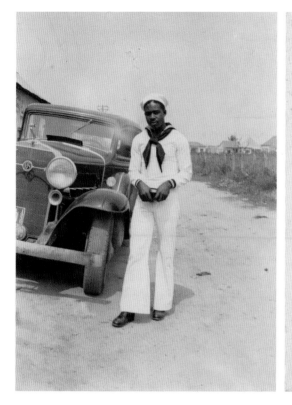

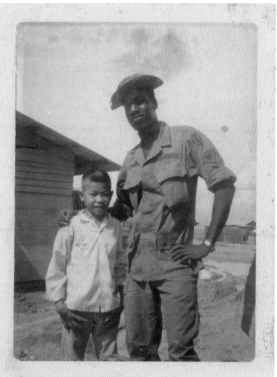

**A Seaman 2nd
Class in front of a
car**, ca. 1939
Unidentified
photographer

**A soldier standing
with a young boy in
Vietnam**, 1968–69
Morris L. Hall

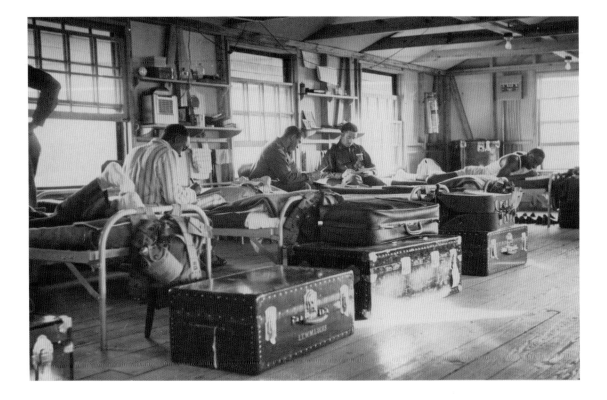

Tuskegee Airmen
writing letters home,
1941–45
Robert Scurlock

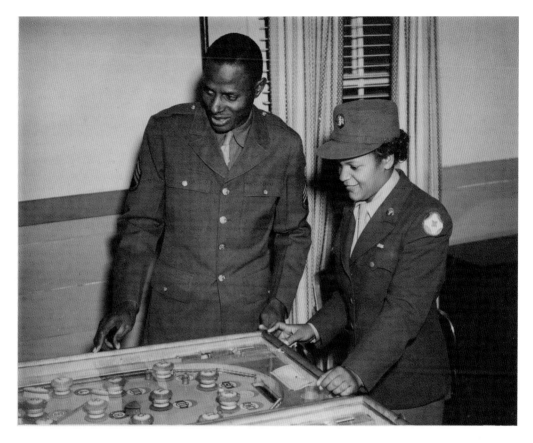

A man and woman in military uniform playing pinball, 1941–43
United States Army
Air Corps

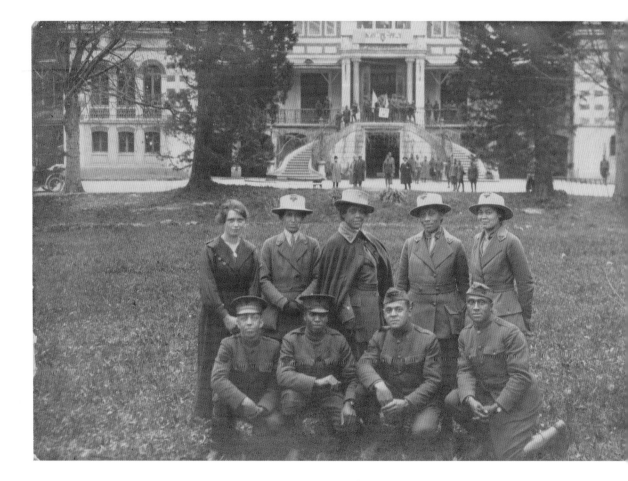

Secretarial Group at Challes-les-Eaux,
1919
Guilleminot

—

During World War I, the Young Men's Christian Association (YMCA) provided places for American soldiers abroad to rest, relax, and socialize. But, extending segregation overseas, the organization provided few services for the African American soldiers serving in Europe. The YMCA asked activist Addie Waites Hunton, who had a history with the organization, to support African American soldiers serving in France. In 1918, Hunton, Kathryn Magnolia Johnson, and Helen Curtis traveled to France to aid the YMCA's programs. Together, the three women were responsible for supporting 200,000 African American servicemen until spring 1919, when an additional sixteen African American women finally arrived. Johnson (back row, second from left) and Hunton (back row, center) are pictured here with two other women in YMCA uniforms in front of the YMCA at Challes-les-Eaux, France. These women worked tirelessly for over a year to organize entertainment, educational activities, social events, and religious services for soldiers. They boosted servicemen's morale by serving refreshments, reading and writing letters for them, and simply talking to them. After the war, Hunton and Johnson returned to the United States and wrote *Two Colored Women with the American Expeditionary Forces* about their experiences abroad.

"It was our privilege to go overseas as welfare workers[s] under the auspices of the Y.M.C.A.... To cheer and encourage; to administer to the spiritual and physical needs; and to establish a connecting link between the soldier and the home; that home which ever kept for him a beckoning candle in the window..."

Addie Hunton and Kathryn Johnson, *Two Colored Women with the American Expeditionary Forces*, 1920

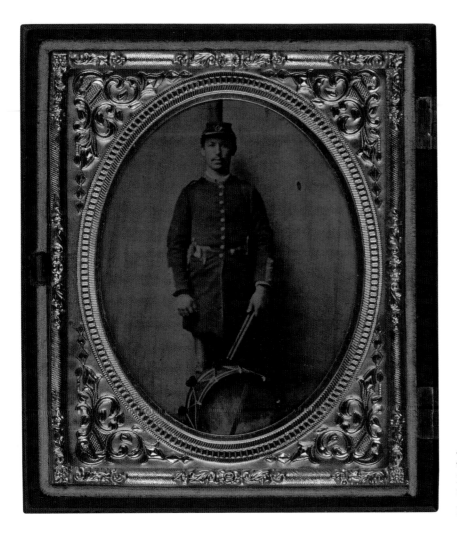

**A Civil War soldier
with a snare drum,**
1860s
Unidentified
photographer

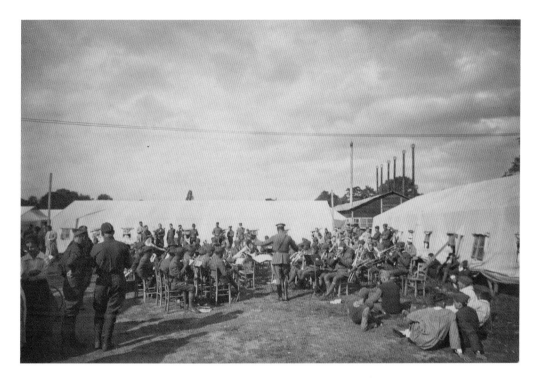

Jim Europe's 369th Infantry "Harlem Hellfighters" Brass Band, ca. 1918
H. G. Ellis
—

In 1918, the celebrated 369th Infantry Regiment band led by Lieutenant James Reese "Jim" Europe toured war-torn France introducing jazz to many Europeans for the first time. Europe recruited African American musicians from all over the country—even traveling as far as Puerto Rico for reed players—for his larger-than-regulation military band. Here, Lt. Europe and his band of "Harlem Hellfighters" is photographed at the American Red Cross Hospital Number 5 in Paris, providing a much-needed dose of musical medicine to soldiers, patients, nurses, and doctors.

**A volunteer serving
troops out of a Red
Cross "Clubmobile,"**
ca. 1945
Unidentified
photographer

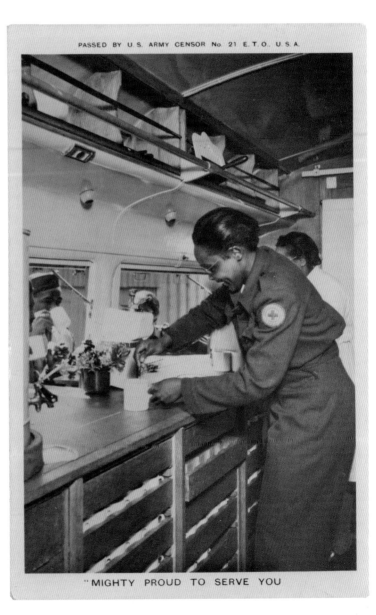

PASSED BY U.S. ARMY CENSOR No. 21 E.T.O., U.S.A.

"MIGHTY PROUD TO SERVE YOU

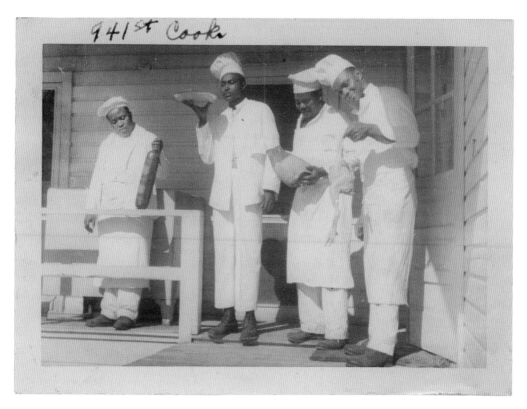

941st Cooks

**Four men in cooks'
uniforms on a porch**,
1941–43
Unidentified
photographer
—

Wars cannot be
successfully waged and
won without thousands of
skilled support personnel.
Morale-boosting cooks
such as these four
men assigned to the

941st Guard Squadron
at Tuskegee Army Air
Field were much more
significant to U.S. victory
during World War II than
history often records.

Postcard of Ellen Scurlock at Meridian Hill Park, Washington, D.C., with poem to Robert Scurlock on back,
1940s
Scurlock Studio

An End to Waiting

The lights will blaze in glory,
No more my thoughts will roam,
And I shall be contented
When Bobby comes marching home...

And all your saved-up kisses
Upon my lips will burn.
There'll be an end to waiting,
When Bobby comes marching home.

By Georgia "Ellen" Love Scurlock

Two American soldiers sitting on a jeep in Vietnam, ca. 1967
James Edward Brown II

—

Black soldiers were drafted to fight in Vietnam during a racially explosive period. DAP (Dignity and Pride) handshakes and soul power fists, a subversive symbol of solidarity and protection, would substitute for the Black Power fists that were prohibited by the military. Additionally, DAP could be used to communicate critical survival information, such as what to expect at the battlefront or what had transpired during an operation. Eventually, DAP was banned at all levels of the military, and thus many black soldiers were court-martialed, jailed, and even dishonorably discharged as a punishment for dapping. DAP handshakes became symbols of unity, kinship, and survival among African American soldiers in Vietnam.

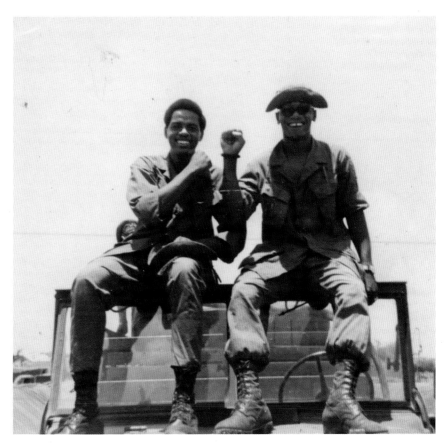

U.S. Navy sailors and an officer at basic training, 1942–45
Eastman Kodak Company

"Should I sacrifice my life to live half American? Will things be better for the next generation in the peace to follow? Would it be demanding too much to demand full citizenship rights in exchange for the sacrificing of my life?"

James G. Thompson, Letter to the Editor, *Pittsburgh Courier*, January 31, 1942

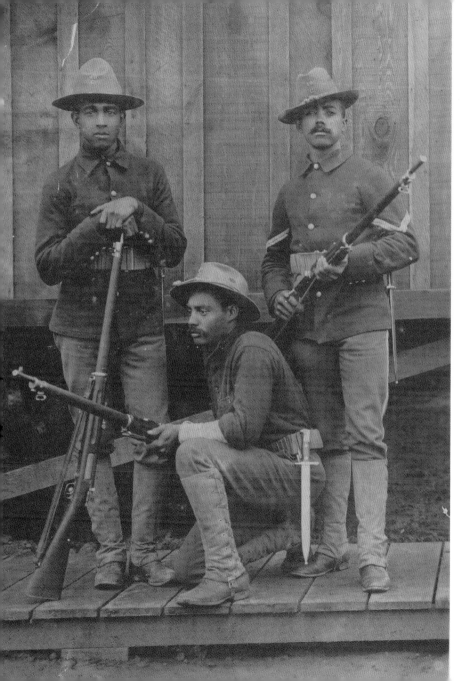

Corporal Scott W. Stewart (right) and two unidentified soldiers of the 49th Regiment at the Presidio in San Francisco, California, ca. 1898 Waterman

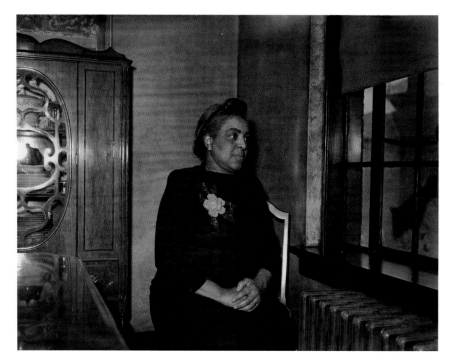

Portrait of Gold Star Mother Mrs. Ulysses Williams Seated beside Window in Domestic Interior, Pittsburgh, Pennsylvania, 1945
Charles "Teenie" Harris

—

Here, Teenie Harris, the pre-eminent black photographer based in Pittsburgh, captures the anguish, pride, and stoicism of a parent whose beloved child was sacrificed to the fight against fascism. Mrs. Ulysses Williams became a "Gold Star Mother" when her son, Private First Class Ulysses Williams Jr., was killed on February 22, 1945. He died in a vehicle accident while serving with a medical unit in Germany. Pfc. Williams was a student in the pre-medical school at the University of Pittsburgh before joining the military in July 1943.

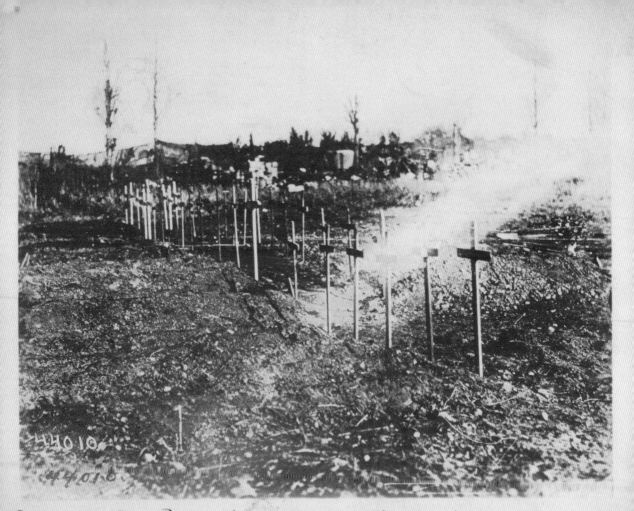

Graves of 92nd Div - Pont du Mosson, Meurthe et Moselle. Nov. 24. 1918

**Graves of the 92nd Division
at Pont-à-Mousson,
Meurthe-et-Moselle,
France**, November 24, 1918
United States Army
Signal Corps

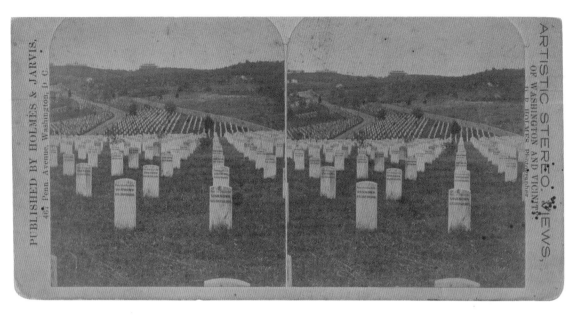

**Headstones of U.S. Colored
Troops at Arlington
Cemetery**, 1872–74
D. R. Holmes

*"How I got out of that fight alive I cannot tell,
but I am here. My Dear girl I hope again to see
you. I must bid you farewell should I be killed.
Remember if I die I die in a good cause. I wish we
had a hundred thousand colored troops—we would
put an end to this war. Good Bye to all."*

Lewis Douglass to Amelia Loguen, July 20, 1863

**Prisoners
being buried at
Andersonville Prison,**
August 17, 1864
Unidentified
photographer

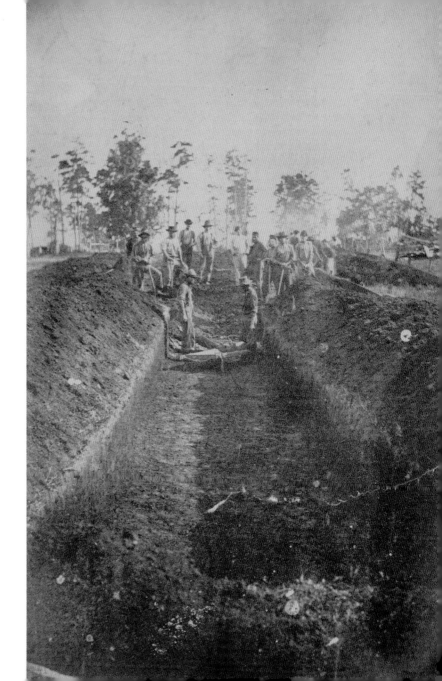

Memories of a Veteran

The horrors of war never leave the minds of soldiers who served in brutal combat. The violent deaths of comrades on the battlefield and the suffering of orphaned children who beg soldiers for coins and C-rations forge vivid, enduring images. In 1952, my father Edward Theodore Taylor returned to the United States after fierce fighting in Korea. A few days before he left, he had his photograph taken in Inchon, Korea, and six decades later, this photograph remains his only physical vestige of the war.

His countenance bears the weight of a nineteen-year-old who has just lived and fought for nine months and twenty-three days in a frigid place the soldiers called "Hell." His mother's weekly letters and her revelation that she prayed for him daily helped him to survive. No doubt, his superior training as a combat infantry ranger, at Schofield Barracks in Hawaii, kept him safe through battle.

In 1953, one year after his return home to Maryland, my father began the cathartic exercise of writing a book about his war experience; however, the unbearable gravity of his harsh memories precluded its completion. Several decades as an educator and anti-war advocate would pass before he could revisit his memoir of the Korean War, a significant conflict that launched the racial integration of the American military. In 2006, he finally completed *Just God and Me: A Korean War Veteran Remembers*, in which he documents tragic events that form the basis of his anti-war sentiments. The front cover of the book bears his evocative image.

Deborah Tulani Salahu-Din, 2016

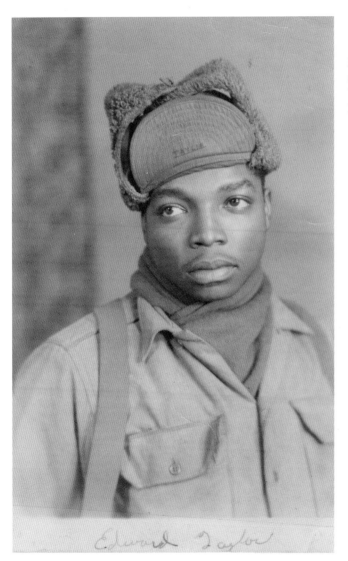

**Edward T. Taylor
in uniform**, 1952
Unidentified
photographer

A couple, mid–20th century
Rev. Henry Clay Anderson

A wedding, ca. 1940s
Unidentified photographer

Index

All of the photographic materials are in the collection of the National Museum of African American History and Culture.

Rev. Henry Clay Anderson
A couple, mid-20th century
gelatin silver print
H × W (Image and Sheet):
3½ × 5 in. (8.9 × 12.7 cm)
Gift of Charles Schwartz and
Shawn Wilson
2012.137.29.81
© Smithsonian National Museum
of African American History and
Culture
Page 67

Staff Sergeant Caleb Barrieau
General Lloyd J. Austin III,
Commander, United States
Central Command, and Former
Commanding General, United
States Forces–Iraq, 2011
digital image
Gift of General Lloyd J. Austin III,
U.S. Army (Ret.)
2016.89.2
U.S. Army photo
Page 55

Cornelius M. Battey
Military training graduation at
Tuskegee Institute, ca. 1916–18
gelatin silver print
H × W (Image and Sheet):
8¹/₁₆ × 10 in. (20.5 × 25.4 cm)
2013.46.30
© Tuskegee Archives
Page 11

James Edward Brown II
Two American soldiers sitting on
a jeep in Vietnam, ca. 1967
gelatin silver print
H × W (Image and Sheet): 3½ ×
3½ in. (8.9 × 8.9 cm)
Gift of James E. Brown
2013.11.4.3
Page 76

Gaston L. DeVigne II
A lieutenant in the Army Nurse
Corps, 1941–45
gelatin silver print
H × W (Image and Sheet):
13¹⁵/₁₆ × 10⁹/₁₆ in. (35.4 × 26.8 cm)
Gift of Gaston L. DeVigne, III in
memory of his parents Gaston
L. DeVigne, II and Yvonne B.
DeVigne
2014.272.14.20
© Gaston L. DeVigne II
Page 34

Eastman Kodak Company
U.S. Navy sailors and an officer
at basic training, 1942–45
ink on paper
H × W (Image and Sheet):
5⅜ × 3½ in. (13.7 × 8.9 cm)
2010.36.5.27
Page 75

H. G. Ellis
Jim Europe's 369th Infantry
"Harlem Hellfighters" Brass
Band, ca. 1918
gelatin silver print
H × W (Images and Sheet):
4⁹/₁₆ × 6¹³/₁₆ in. (11.6 × 17.3 cm)
2011.57.39
Page 63

Leonard Freed
West Berlin ● Germany, 1967;
printed 2006–9
gelatin silver print
H × W (Image and Sheet):
11 × 14 in. (27.9 × 35.6 cm)
Gift of Brigitte Freed in memory
of Leonard Freed
2009.36.12
© Leonard Freed/Magnum
Page 52

Guilleminot
Secretarial Group at Challes-
les-Eaux, 1919
gelatin silver post card
H × W (Image and Sheet):
3⁹/₁₆ × 5⅞/₁₆ in.
(9 × 13.8 cm)
2014.63.77
Page 61

Morris L. Hall
A soldier standing with a young
boy in Vietnam, 1968–69
gelatin silver print
H × W (Image and Sheet):
3¼ × 2½ in. (8.2 × 6.4 cm)
2011.155.144.9c
Page 57

Charles "Teenie" Harris
Portrait of Gold Star Mother Mrs.
Ulysses Williams Seated beside
Window in Domestic Interior,
Pittsburgh, Pennsylvania, 1945
gelatin silver print
H × W (Image and Sheet):
9 × 11 in. (22.9 × 27.9 cm)
Gift from Charles A. Harris and
Beatrice Harris in memory of
Charles "Teenie" Harris
2014.302.73
© Carnegie Museum of Art,
Charles "Teenie" Harris Archive
Page 73

Specialist Nicholas Hernandez
U.S. Army Lt. Gen. Lloyd J.
Austin III, Commander of the
XVIII Airborne Corps, U.S.
Army Col. Jeffrey L. Bannister,
Commander of the 2nd Infantry
Brigade Combat Team, and Iraqi
Brig. Gen. Abdullah Discuss Troop
Progress during a Meeting in East
Baghdad, Iraq, on Sept. 11, 2007
digital image
Gift of General Lloyd J. Austin III,
U.S. Army (Ret.)
2016.89.1
U.S. Army photo
Page 54

O. M. Hofsteater
Private Thomas White, Company
B, 24th U.S. Infantry, 1899
gelatin silver cabinet card
H × W (Image and Mount):
6½ × 4¼ in. (16.5 × 10.8 cm)
2014.37.5
Page 28

D. R. Holmes
Headstones of U.S. Colored
Troops at Arlington Cemetery,
1872–74
stereograph
H × W (Image and Mount):
7 × 3⅜ × ¹/₁₆ in. (17.8 × 8.6 × 0.1 cm)
2014.37.7.6
Page 71

A. P. Mitchell
Corporal Lawrence McVey
in uniform, 1917–19
ink on paper
H × W (Image and Sheet):
5⁷/₁₆ × 3⁷/₁₆ in. (13.8 × 8.7 cm)
Gift of Gina R. McVey, grand
daughter
2011.108.17
Page 27, front cover

Office of War Information
Captain Della H. Raney at the
station hospital at Camp Beale,
California, April 11, 1945
gelatin silver print
H × W (Image and Sheet):
8⅛ × 10 in. (20.6 × 25.4 cm)
2014.63.81
Page 32

James H. O'Neal
Joe Louis and Commander Benjamin O. Davis Jr. at Ramitelli Airfield, Italy, 1944
gelatin silver print
H × W (Image and Sheet):
8 × 10 in. (20.3 × 25.4 cm)
Gift of the O'Neal family in loving memory of James "Huey" O'Neal
2015.63.1
© Andrea M. O'Neal
Page 39

James H. O'Neal
Tuskegee mechanic servicing a P-51 Mustang, 1941–45
gelatin silver print
H × W (Image and Sheet):
5 × 4 in. (12.7 × 10.2 cm)
Gift of the O'Neal family in loving memory of James "Huey" O'Neal
2015.63.4
© Andrea M. O'Neal
Page 37

Pach Brothers
Charles Young as a cadet at West Point, 1889
cabinet card
H × W (Image and Mount):
6½ × 4¼ in. (16.5 × 10.8 cm)
2011.57.21
Page 15

John Ritchie
Sergeant William Carney holding a flag, ca. 1864
albumen cabinet card
H × W (Image and Page):
6¼ × 5 in. (15.9 × 12.7 cm)
Gift of the Garrison Family in memory of George Thompson Garrison
2014.115.8
Page 26

C. Bruce Santee
Peter L. Robinson Sr., ca. 1917
gelatin silver print
H × W (image and mount): 9⅞ x 7⅞ in. (25.1 × 20 cm)
Gift of Peter L. Robinson, Jr. and Marie Robinson Johnson
2010.18.1
Page 31

Scurlock Studio
Postcard of Ellen Scurlock at Meridian Hill Park with poem to Robert Scurlock on back, 1940s
gelatin silver postcard
H × W (Image and Sheet):
4¹¹⁄₁₆ × 6⅝ in. (11.9 × 16.8 cm)
Gift of the Scurlock family
TA2014.306.4.1.3
Page 66

Robert Scurlock
Major Lee Rayford in front of a P-47 Thunderbolt, 1944–46
gelatin silver print
H × W (Image and Sheet):
13⅞ × 11 in. (35.2 × 27.9 cm)
Gift of the Scurlock family
TA2014.306.2.3.6
Page 36, frontispiece

Robert Scurlock
A soldier taking a photo, 1942–45
gelatin silver print
H × W (Image and Sheet):
3¹⁵⁄₁₆ × 3¹³⁄₁₆ in. (10 × 9.7 cm)
Gift of the Scurlock family
TA2014.306.2.1.40
Back cover

Robert Scurlock
Tuskegee Airmen writing letters home, 1941–45
gelatin silver print
H × W (Image and Sheet):
4¹⁵⁄₁₆ × 7¹⁄₁₆ in. (12.5 × 17.9 cm)
Gift of the Scurlock family
TA2014.306.3.1.5
Page 58

Strohmeyer & Wyman
A parade of the Grand Army of the Republic in Louisville, Kentucky, 1895
stereograph
H × W (Image and Mount):
3⁹⁄₁₆ × 6¹⁵⁄₁₆ in. (9 × 17.7 cm)
2015.248.6
Page 6

Thompson Illustrograph Company
Just Back from France, February 1919
gelatin silver print
H × W (Image and Sheet): 8 × 44⁵⁄₁₆ in. (20.3 × 112.6 cm)
Gift of the University of Hawai'i at Manoa, Department of Art and Art History
2016.32.1
Page 30, gatefold

Underwood & Underwood
Fighting from Stone Wall Defences – Washington Volunteers – Taguig, Philippines, 1899
gelatin silver stereograph
H × W (Image and Mount):
3⅜ × 7 in. (8.6 × 17.8 cm)
2014.37.7.10
Page 48

Unidentified photographer
Anthony Barboza in a naval uniform holding cameras, 1966
gelatin silver print
H × W (Image and Sheet):
9¹⁵⁄₁₆ × 8¹⁄₁₆ in. (25.3 × 20.4 cm)
2016.99.6
© Anthony Barboza
Page 9

Unidentified photographer
Bosey E. Vick, 1914–18
gelatin silver print
H × W (Image and Sheet):
10 × 8 in. (25.4 × 20.3 cm)
Gift of Jackie Bryant Smith
2010.66.75
Page 29

Unidentified photographer
C. Alfred "Chief" Anderson, Major "Chappie" James Jr., and Daniel James III at Otis Air National Guard Base, Massachusetts, August 1955
gelatin silver print
H × W (Image and Sheet):
3⁷⁄₁₆ × 4¹⁵⁄₁₆ in. (8.8 × 12.5 cm)
Gift of Charles Alfred Anderson, Jr. in memory of Chief C. Alfred Anderson
2015.57.2
Page 17

Unidentified photographer
Captain William A. Prickitt's photograph album of the 25th Regiment USCT soldiers, 1864–65
albumen prints and tintypes
H × W × D (Album open):
2 × 4 × ⅞ in. (5.1 × 10.2 × 2.2 cm)
H × W × D (Album closed):
2 × 1¹³⁄₁₆ × ⅞ in. (5.1 × 4.6 × 2.2 cm)
Gift of Aneita Gates, on behalf of her son, Kameron Gates, and all the Descendants of Captain William A. Prickitt
2014.88a–r
Page 20

Unidentified photographer
Carl Brashear running, after 1966
gelatin silver print
H × W (Image and Sheet):
8 × 11¼ in. (20.3 × 28.6 cm)
Gift of the Carl Brashear Foundation
2014.66.7
Page 33

Unidentified photographer
A Civil War soldier with a snare drum, 1860s
tintype
H × W × D (Case open):
3¾ × 6¾ × ⅜ in. (8.3 × 17.1 × 1 cm)
H × W × D (Case closed):
3¾ × 3⅜ × ⅞ in. (8.3 × 8.6 × 2.2 cm)
2011.155.161
Page 62

Unidentified photographer
Creed Miller's star-shaped military identification pin and photo, 1864
tintype
H × W × D (Case open):
2¹⁵⁄₁₆ × 5¼ × ⁷⁄₁₆ in. (7.5 × 13.3 × 1.1 cm)
H × W × D (Case closed):
2⅞ × 2⅝ × ⁹⁄₁₆ in. (7.3 × 6.7 × 1.4 cm)
2011.155.294ab
Page 22